GAME OF THRONES

THRONES

THE JOURNEY OF
ARYA STARK

T0364082

RP Minis™
Hachette Book Group
1290 Avenue of the Americas, New York, NY 10104
www.runningpress.com
@Running_Press

First Edition: September 2023

Published by RP Minis, an imprint of Perseus Books, LLC, a subsidiary of Hachette Book Group, Inc. The RP Minis name and logo is a registered trademark of the Hachette Book Group.

Running Press books may be purchased in bulk for business, educational, or promotional use. For more information, please contact your local bookseller or the Hachette Book Group Special Markets Department at Special.Markets@hbgusa.com.

The publisher is not responsible for websites (or their content) that are not owned by the publisher.

ISBN: 978-0-7624-8343-3

CONTENTS

INTRODUCTION

Stoic, brave, and steadfast, House Stark ruled the North for generations from the halls of their ancestral home at Winterfell. Arya Stark, youngest daughter of Lord Eddard and Lady Catelyn, spent her early years dreaming of the chance to become a warrior like her older brothers. Little did she know what hardships and heroics chasing that dream would entail or the moments of truth to which they would lead her.

WINTER IS COMING

When her father, Ned Stark, is
made the king's chief advisor
(aka the Hand of the King), Arya
travels with him and her sister,
Sansa, to the seat of royal powe

at King's Landing. She brings along Needle, a sword given to her by her half brother, Jon.

In King's Landing, Ned hires the Braavosi swordsman Syrio Forel to give Arya sword-fighting lessons. When the king dies and Ned is arrested for questioning the parentage of Prince Joffrey, heir to the throne, Syrio helps Arya escape. A stable boy threatens to turn Arya in, but by accident, she fatally stabs him—her first kill.

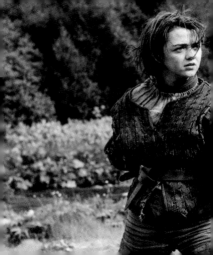

On the day of her father's execution, Arya rushes through the crowd to try to save him. But before she can, she is grabbed by her father's friend Yoren, a sworn brother of the Night's Watch, who cuts her hair, renames her Arry the Orphan Boy, and takes her north with his caravan of criminals on their way to the Wall, where she can reunite with her brother.

IN THE LION'S DEN

Soldiers from House Lannister stop the caravan, kill Yoren, and arrest his prisoners. Before being captured, Arya manages to free the criminal Jaqen H'ghar and

two others. The soldier Polliver takes Needle from her, mocking its thinness by saying he'll use it to pick his teeth. Arya is brought to Harrenhal—once the largest castle in the Seven Kingdoms, but now mostly ruins—where Tywin Lannister, head of House Lannister, makes her serve as his cupbearer.

Jaqen H'ghar promises Arya three lives as thanks for saving him and the others. Arya immediately orders him to kill Harrenhal's

head torturer, who has been bait-
ing rats to chew into the bellies
of several prisoners. Meanwhile,
at night, Arya begins reciting a
list of all the people she plans
to murder.

Arya learns about her brother
Robb's successes against Joffrey's
army, which had prompted Tywin
to launch a surprise attack. Arya
asks Jaqen to kill Tywin, but he's
unable to do so before Tywin
leaves the castle. Instead, she
forces Jaqen to help her escape

with her friends Gendry and Hot Pie, which he does by secretly murdering Harrenhal's entire gate guard. In awe of his skills, Arya asks to learn them. Jaqen gives her a special coin and tells her that if she gives it to any Braavosi and says, "*Valar morghulis,*" they will take her to him.

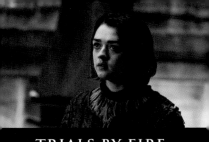

TRIALS BY FIRE

On the road, Arya and her friends run into Beric Dondarrion, leader of the Brotherhood Without Banners—an outlaw band that fights to defend the smallfolk

Arya is identified by Joffrey's former bodyguard Sandor Clegane, known as the Hound, who has been captured by the Brotherhood. Beric decides to take her to her family to claim the reward. But when Arya reveals that the Hound killed an innocent child on the road to King's Landing, Beric insists the Hound must face him in trial by combat. After the Hound wins, Arya tries to kill him herself, but Beric lets him go.

Soon after, Melisandre, a red priestess of R'hllor, arrives at the camp and claims she needs Gendry for a special mission. Arya challenges her, and Melisandre responds by saying she sees the brown, green, and blue eyes of Arya's future victims staring back at her. Disgusted with Beric's willingness to sell Gendry for money, Arya flees the Brotherhood but is immediately captured by the Hound.

The Hound takes Arya to her mother and brother Robb at the Twins, a fortified river crossing held by House Frey, which the Freys have supposedly agreed to let the Stark army use. But as Arya and the Hound arrive, the Freys suddenly begin slaughtering Robb's army. Arya wants to save her family, but the Hound insists that it's too late. Riding away, Arya sees Robb's body on horseback, with the head of his direwolf, Grey Wind, where his own should be.

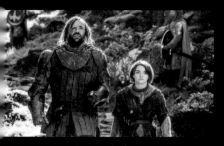

NEEDLE AND THE HOUND

The Hound decides to bring
Arya to her rich aunt, Lysa, at
the Eyrie, the mountain home of
House Arryn. On the road, Arya

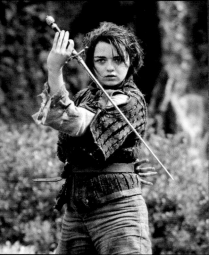

discovers Polliver, still carrying Needle, with a group of Lannister soldiers. A battle ensues, resulting in Arya stabbing Polliver—slowly—through the head while repeating the words with which he originally taunted her.

As they travel to the Eyrie, the Hound teaches Arya about the need to see reality in all its bleakness and not to be deluded by hope or goodwill. They arrive to learn that Lysa had died three days earlier.

Soon after the pair leaves the
Eyrie, they come upon the knight
Brienne of Tarth and her squire,
Podrick Payne. Brienne claims
she promised Catelyn she would
protect Sansa and Arya. But upon

seeing Brienne's Lannister-made sword, the Hound insists she's lying. The two battle, and the Hound is bested by Brienne, who pushes him over a cliff. Horribly injured from the fall, the Hound begs Arya to kill him; instead, she silently steals his money and leaves him to die.

At a nearby port, Arya shows Jaqen's coin to a Braavosi captain and says, "*Valar morghulis*," and he agrees to take her to the Free City of Braavos.

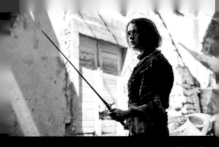

THE GAME OF FACES

At the House of Black and White, home of the guild of assassins known as the Faceless Men, Arya quickly becomes frustrated with

by her mentor, Jaqen. From the Waif, another servant of the guild, Arya learns the Game of Faces, which entails being hit each time she truthfully answers the question of who she is. Jaqen observes that Arya continues to hold on to much from her past, despite saying she wants to become a Faceless Man, who is no one. In response, Arya throws her possessions into the sea, save for Needle, which she hides under some stones near the water.

When Arya next plays the Game—this time with Jaqen—she mixes truth with lies, yet still gets hit repeatedly, as her mentor is not fooled by her lies. When a father brings his suffering daughter to the House of Black and White seeking to end her pain, Arya makes up a story about how the House's waters once healed her, prompting the girl to drink from the secretly poisonous waters and perish.

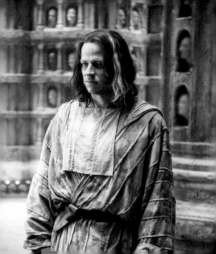

After this encounter, Jaqen shows Arya a chamber filled with masks, each of them the face of someone killed by the Faceless Men, who use the masks to change their forms. He tasks Arya with murdering a greedy old man who bankrolls ships' captains on the docks. Before Arya has her chance, she is distracted by the arrival of Meryn Trant, the man who killed her teacher, Syrio Forel, and she spends the day following him instead.

Seeing that Trant has a taste for young girls, Arya steals the face of the girl to whom she lied about the poisonous waters in the chamber and sets herself up to be Trant's next conquest. As he advances on her, she stabs his eyes out, then slits his throat as she reveals her true identity.

Jaqen tells Arya that in killing Trant instead of the old man, she has stolen a life from the Many-Faced God (aka Death), a debt that must be paid. He kills himself

in front of her, and she suddenly
goes blind—poisoned by the use
of the girl's face.

VALAR MORGHULIS

Now a street beggar tormented by the Waif, Arya encounters a new Faceless Man wearing Jaqen's face. He offers her shelter, food, or her sight if she says who she is. After Arya repeatedly insists that she's no one, the new Jaqen takes her back to the House of Black and White.

The Waif works with Arya on lying and how to fight without being able to see. Eventually Arya can hold her own at both. Pleased,

Jaqen cures her blindness and orders her to kill Lady Crane, an actress in a traveling company. He warns her that if she does not do the job, she will be killed instead. But after meeting Lady Crane, Arya cannot go through with it. Recovering Needle, she pays a ship's captain to take her home to Winterfell. But before she can leave, she's stabbed by the Waif in disguise.

After a chase through the city, the Waif corners Arya in a dark

chamber. Arya uses Needle to take out the lights, hiding what happens next. Jaqen later discovers the Waif's bloody face among the masks. He tells Arya she is finally no one. She insists that no, she is Arya Stark, and she's going home.

In Westeros, Arya, wearing the face of a servant girl, takes revenge on Walder Frey by feeding him his own sons—cooked into a pie—before slitting his throat and poisoning all of his male heirs.

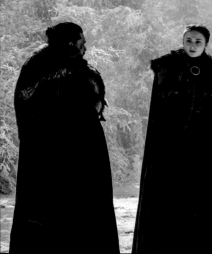

HOUSE STARK

As Arya is heading to King's Landing to cross another name off her list—Queen Cersei, who allowed her father, Ned, to be beheaded—Arya learns that her brother Jon has become king in the North. Returning to Winterfell, she is reunited with siblings Sansa and Bran. Bran offers her the Valyrian steel dagger that was used by an unknown person's catspaw in a failed assassination attempt upon him.

As Sansa observes Arya training with Brienne, she is disturbed by her sister's bloodthirsty skill.

After Arya witnesses Petyr Baelish (known as Littlefinger), Sansa's main advisor, receive something in secret, she breaks into his chamber. There she finds the letter Sansa was forced to write long ago, in which she calls Ned a traitor. When confronted, Sansa insists that she was forced to write it. But it's clear that Arya does not trust her.

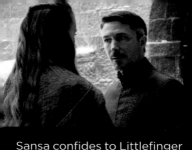

Sansa confides to Littlefinger her fear that her sister might betray her. After he suggests Arya wants to be Lady of Winterfell herself, Sansa has Arya arrested. But at the hearing, Arya, Sansa, and

Bran reveal it to be a ruse, instead exposing to the assembled group Littlefinger's many crimes, including betraying their father and being responsible for the catspaw who tried to kill Bran. At Sansa's order, Arya kills Littlefinger with the catspaw dagger.

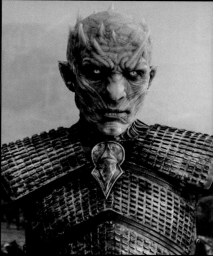

THE LONG NIGHT

The Night King—a blazingly blue-eyed undead creature intent on killing all living beings and creating an eternal sunless winter with his endless army of the icy dead—launches his attack upon the armies gathered to oppose him at Winterfell. For a while, Arya holds her own, but eventually the numbers overwhelm her. Disheartened and frightened, Arya stumbles upon Melisandre in the castle, who reminds Arya of the vision

she had, in which Arya killed peo-
ple with eyes of different colors,
including blue. Understanding
what she must do, Arya rushes
off to surprise the Night King
just as he is about to slay Bran.
The Night King seizes her by the
throat and arm as she leaps at
him, catspaw dagger in hand.
But then she drops the dagger
into her free hand and stabs him
in the chest. Immediately, he and
his entire army shatter. All of
Westeros is saved.

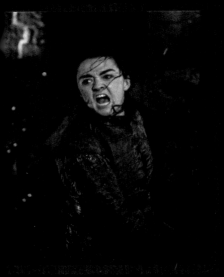

After the battle, Jon insists that his forces join those of Daenerys Targaryen, who he believes has the strongest claim to leadership of the Seven Kingdoms. Arya warns him about trusting Dany more than his family, then travels with the Hound to King's Landing to finally kill Cersei. Upon seeing the destruction that Dany and her forces are wreaking upon the city, the Hound begs Arya to leave before it's too late for her. Arya relents, finally letting go of her

need for revenge. She flees, only barely surviving the collapse of the city around her.

Once Jon kills Dany and Bran is made king, Arya reveals that she won't be staying Westeros. She leaves her siblings behind as she sets sail, intent on finding what lies beyond the edge of the world.

This book has been
bound using handcraft
methods and Smyth-sewn
to ensure durability.

Designed by Mary Boyer.
Written by Jim McDermott.